The Big Girl Colorbook III
BACK OVER THE HILL TO McCLOUD
Color Pages and Poems Inspired By Home

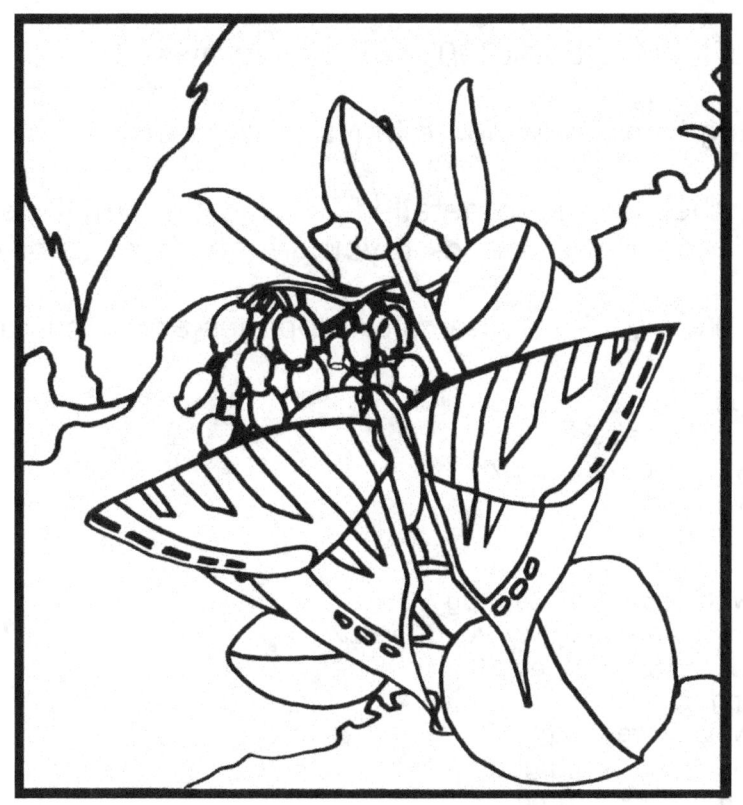

In 2016 I was inspired to create a coloring book on CreateSpace with sketches of Mount Shasta from my photo collection. Then I created a coloring book of flowers and a book of poems dedicated to my motorcycle riding girlfriends.

My work was so well received in my home town of McCloud that I thought a coloring book of mountain images from the McCloud side of Mount Shasta would be in order. Then, I decided to drop in some poetry, inspired by the area and the people who lived and still live there. Here, you have my 2017 coloring AND poetry book inspired by my home stomping grounds – <u>McCloud, California</u>.

W. A. Welbourn – Mount Shasta
(All Rights Reserved)

COVER: Ski Park View

I started digital photography in the 1990's. With Mount Shasta as a focal point I

have a lot of opportunity to practice. 12 of these sketches are from personal photos. Sketch #5 was inspired by a beautiful morning photograph by Tony Kydd. The sketches are of Mount Shasta, starting at Ski Park Highway, no further west...pinky promise!

I did not live in McCloud in the 1990's. I moved away in the 1970's as a young twenty-something to view the world. I came back for a few years before marrying and moving to my new home in Mt. Shasta City in the 1980's.

Some of these sketches are quite detailed. There are small inspiration photos to refer to on the back cover of this book if you get stuck for color or content.

CONTENTS: From West to East (The coloring pages are in horizontal layout).

- Ski Park View, pg 3
- South Gate Meadows, pg 5
- Mount Shasta with Red Barn, pg 7
- Rail Road Crossing, pg 9
- Tony's Inspiration, pg 11
- Spring Mountain, pg 13
- Mount Shasta with Lenticular Cap, pg 15
- Mount Shasta from Squaw Valley Road, pg 17
- Golf Course View from No. 8, pg 19
- Hoo Hoo View, pg 21
- Mount Shasta with Butterfly, pg 23
- The Indian In The Mountain, pg 25
- The Sunset From Vista Point, pg 27

Coloring has been noted to be very relaxing and cathartic, a way to unplug from the stress of the day. It's OK for an adult to enjoy coloring!

Find a comfortable, quiet spot to spend some time. Use colored pencils or wet markers. If you use markers, consider removing the page from the book to work on a blotter. There is a blank page at the end of the coloring section that can be carefully removed and used as a blotter between pages.

As you color, enjoy the magic that Mount Shasta creates.
If you need inspiration please see my blog:
www.TBGCB.blogspot.com
This Google blog uses cookies to track visits.

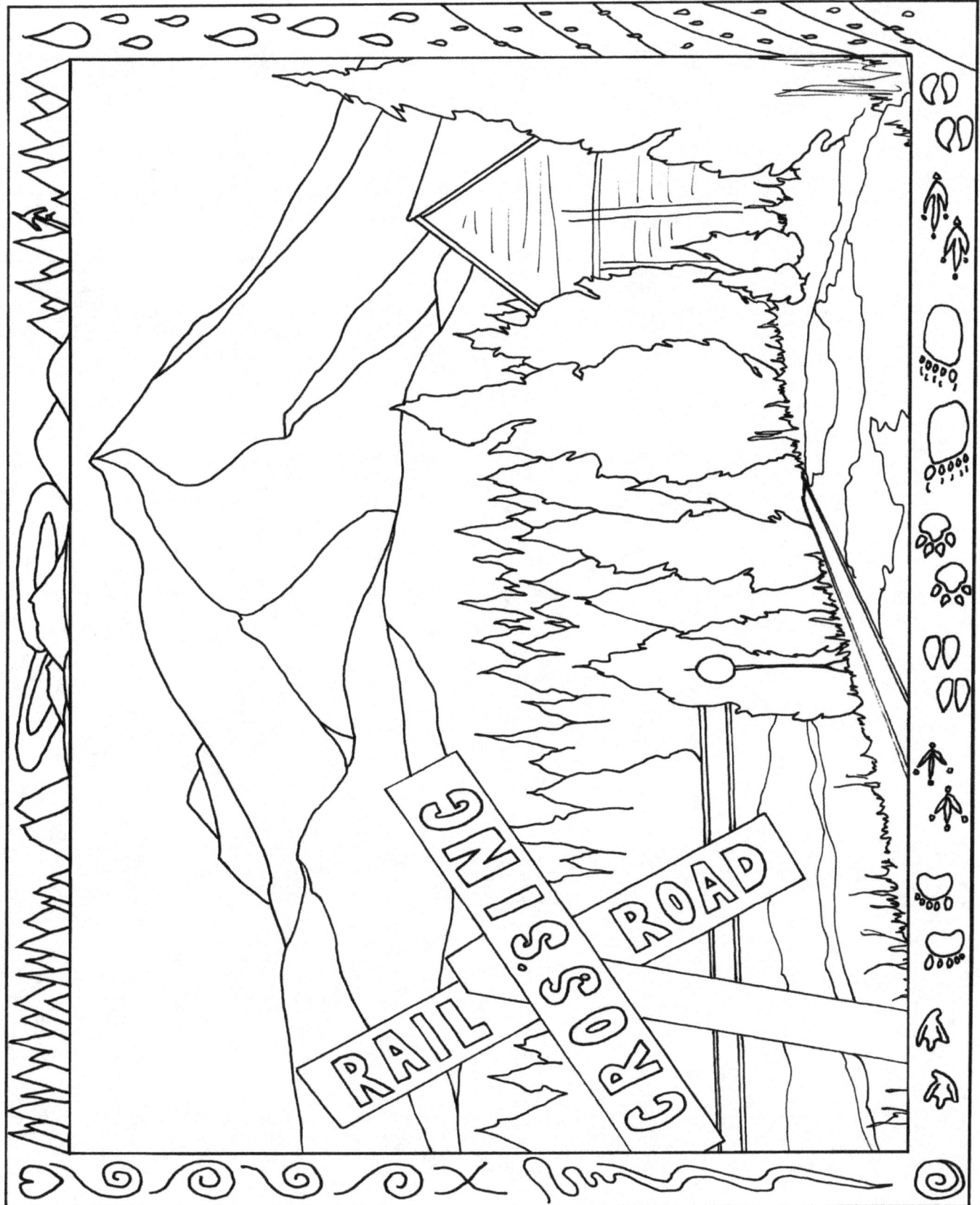

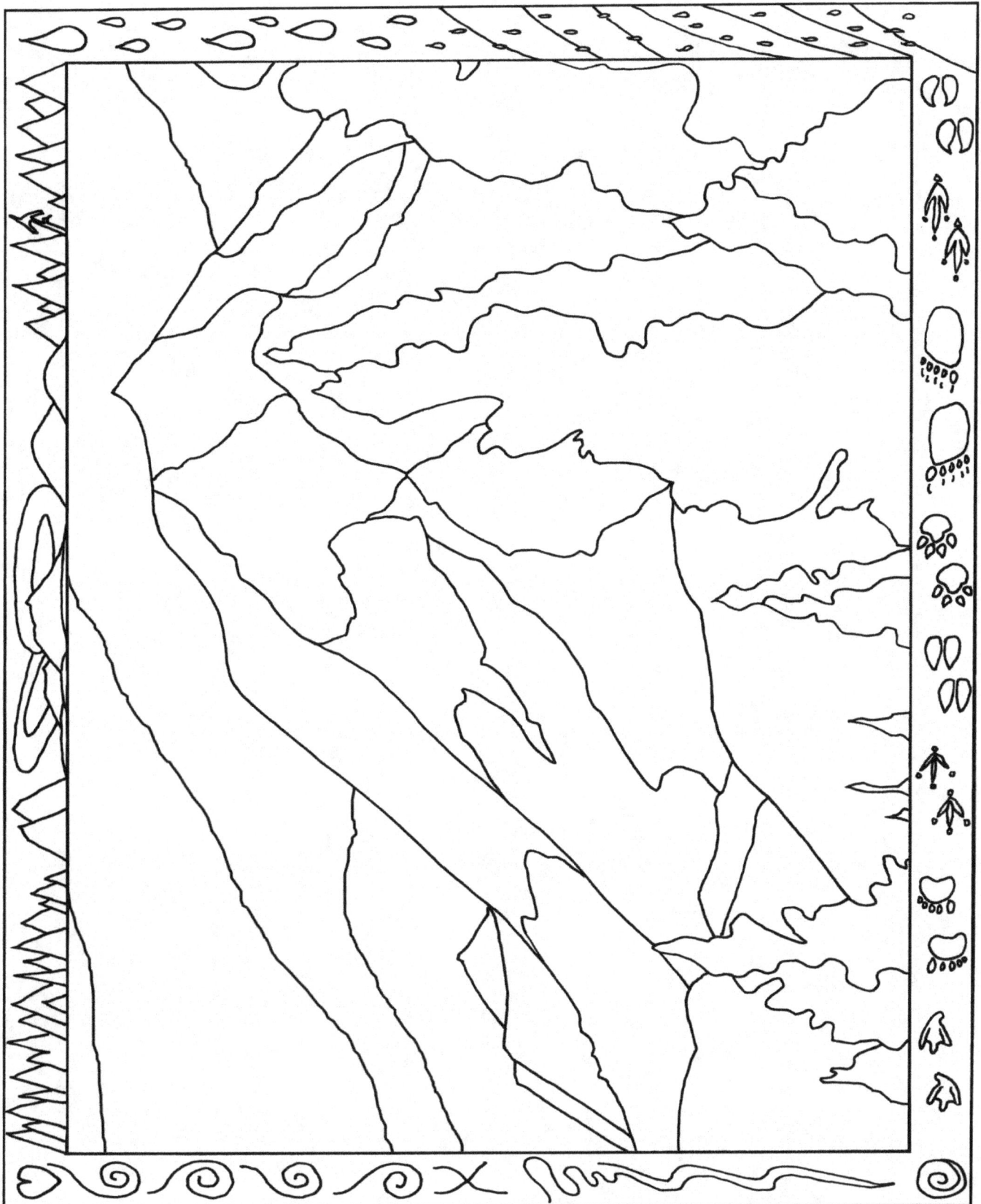

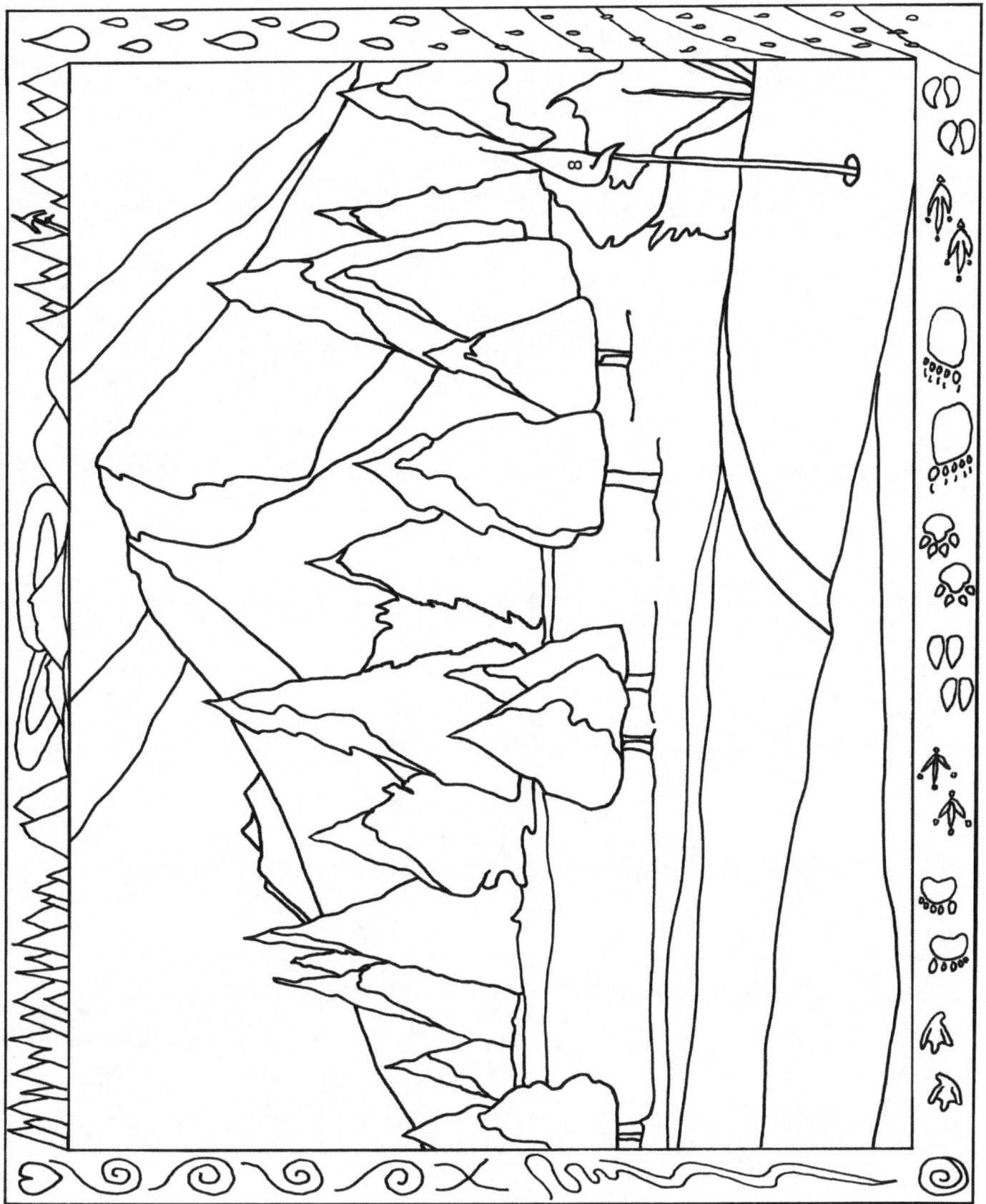

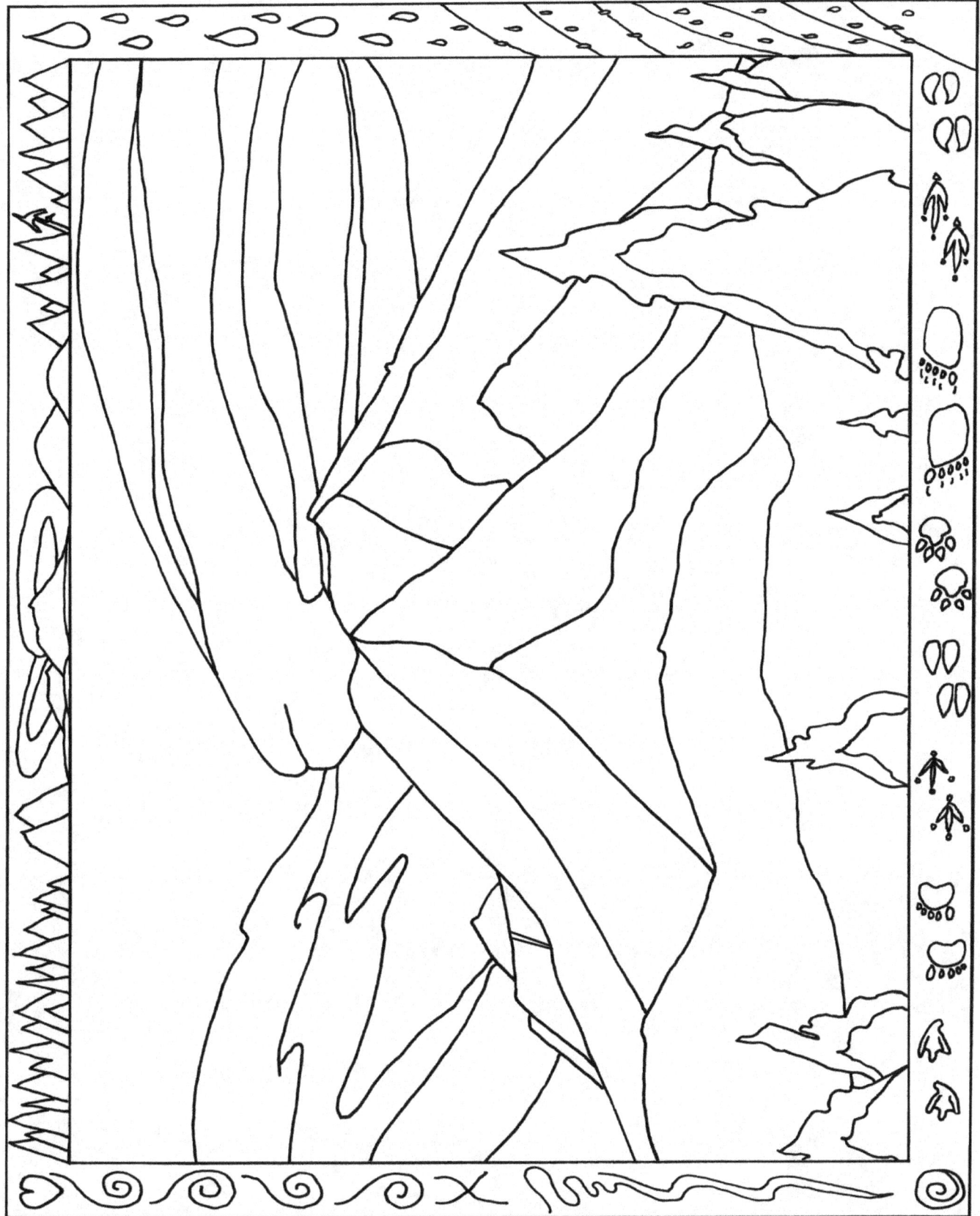

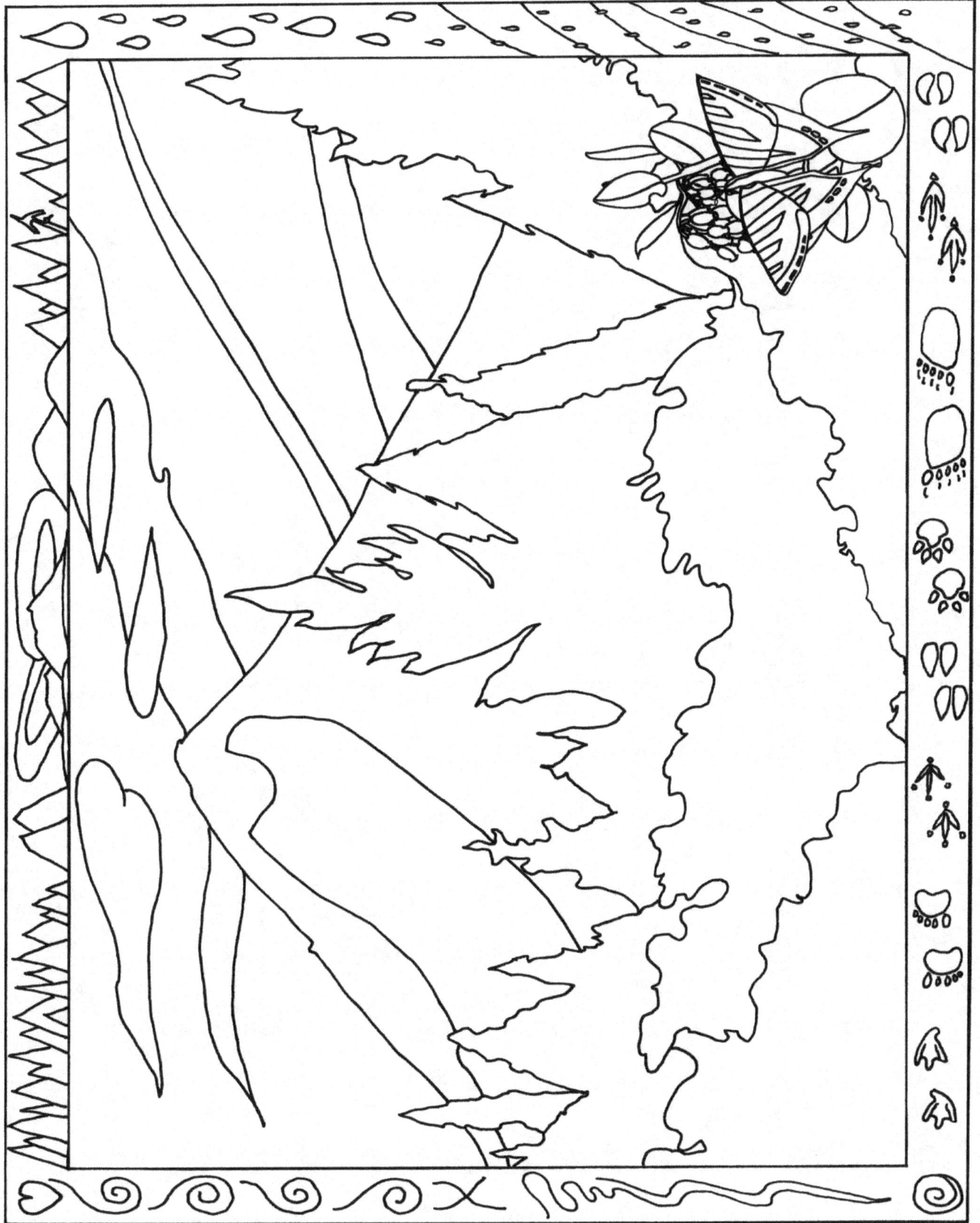

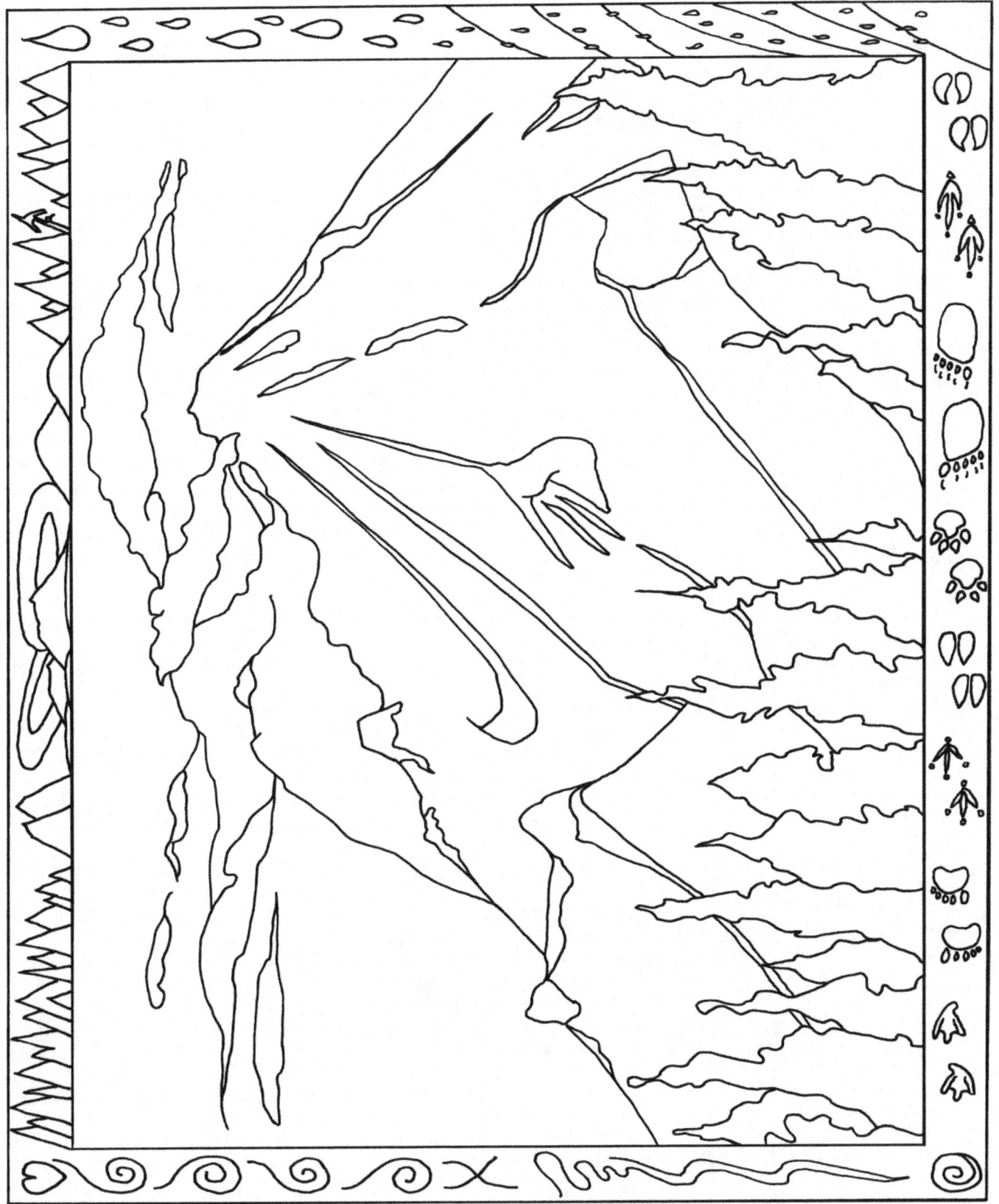

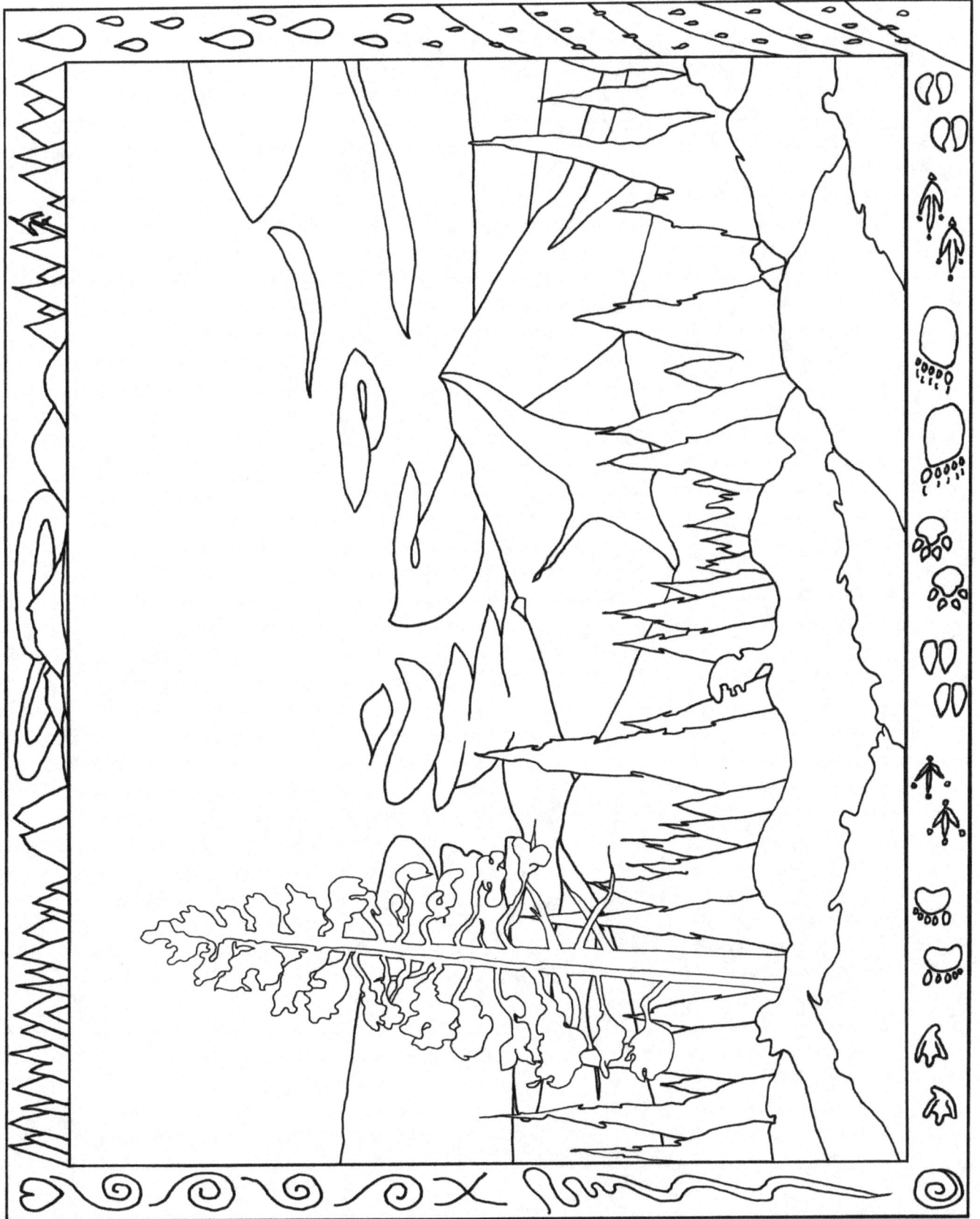

BLOTTER PAGE

BLOTTER PAGE

PROSE AND POEMS INSPIRED BY HOME
by Wanda Welbourn

The following poems are inspired by my home town and the people who live or lived there. Also by Mount Shasta, the McCloud River and the surrounding wild country, where you could find a place to think and breathe.

CONTENTS: (All pages are in vertical layout!)

- Home To McCloud, pg 32
- Picket Fences, pg 33
- Companion, pg 34
- Squirming Bundle, Grainy Pictures, pg 35
- When Women Dance, pg 36
- Another Woman Just Like Me, pg 37
- I loved You Forward, pg 38
- Back Country Haiku, BreathingSkiing, pg 39
- When You Leave, All The Earth Is Holy, pg 40
- You Complete Me, pg 41
- We Are All A Part, pg 42
- Bliss, CatchUs, pg 43
- Spirit Family Home, pg 44
- My Little Life, pgs 45, 46, 47, 48

Home to McCloud

There's nothing like the feeling of going home.
Dropping down from the summit on 89.
Sharp left turn onto Columbero.
Follow the S curves in to town.
The old highway goes my way.
Past the old buildings.
The Guest House, the Hospital,
Grandma and Grandpa's.
Sharp left corner on California
"Slide away Baby!"
Dad would warn ya.
It's like no other feeling I've ever known.
I love the feeling of going home.

Picket Fences

When we were small a picket fence was customary.
Some were painted white and some plain wood.
For us kids it was a test to see who could walk it best,
And if we walked it, well, we knew that we were good.

Picket fences are made from picket slats,
Nailed to 2x4's, some are pointed, some are flat.
Al Ferguson's fence was tall and had the skinniest pickets of all.
We felt like Walendas if we managed to walk that.

There's a comparison to draw about that 2x4.
Where we placed one foot ahead each shaky step.
And the changes in our lives now that we're husbands and/or wives,
And the decisions that we make now we're grown-up.

With every step we take, there's a chance that we might break,
There's a chance that we may stumble or may fall.
But when we gain our balance, we give our selves the chance
To succeed and that's the greatest feat of all!

If it's fences when we're kids, or decisions when we're big,
We're the only ones who know we've done our best.
If we land upon our seat, or land upon our feet
The attempt is a sure measure of success.

Companion *

Once, I sat beside a rock.
It was the most
companionable rock
I ever knew.

We sat together.
Silently.
As rocks and people
sometimes do.

As we sat,
the wind sang us
it's life song.

Unaware of us
as they passed,
a doe and fawn.

An aged pine tree
danced it's silent,
ageless dance.

The rock and I,
we sat,
entranced.

Together we watched
the sun go down.
Then I drove
back to town.

*Published in "The Well Versed Anthology, 1996"

Squirming Bundle

There is a picture of my Mother.
On a short reel of old family film.
She is warmly dressed for winter.
Dark, curling hair wrapped in a scarf.
Her coat buttoned to her chin.
She holds the squirming bundle
that is my infant sister.
Whilst I let the giant steering wheel of
Dad's truck support my toddling form.
She looks up smiling,
Says something to the camera.
For once not mad but anxious to get on.
That is the picture I would show you.
The growing family in a small mill town.
The full moon would not let me sleep
'till I got up to write this down.

Grainy Pictures

Grainy Pictures
They mean so much to me.
They show what was
And hint at what might be.

Grainy pictures
Treasures that I hold.
Each family member
A jewel. Their beauty bold.

Grainy Pictures
Link me to the past.
Family memories made
Are those that last.

(For Ranie
Happy Mother's Day
May 13, 2007)

When Women Dance

There is joy in the steps
of women dancing.
1, cell-e-brate,
2, cell-e-brate
No slow dance for two
But fast for a slew
Of women
Who
Know the magic.
A fast 2, 2 rhythm
Or 1, 2, 3, 4
Hearts beat,
Bodies move,
Sharing the timing.
A young bride is dancing
Encircled by women
All ages and backgrounds
Who love and support her.
Everyone's watching
But it doesn't matter.
There is joy in the steps
of women dancing.

Another Woman Just Like Me

Another woman just like me.
All round and big and comforting.
Became my teacher
And my friend
Then flew away
to Never-land.

But there are things we share
So we are never far apart.
A joyous thought.
A sip of tea.
Drum beat.
Beating heart.

We are separated only by distance
The blue sky belongs to us.
Night stars light our way.
A bird's call, waves rushing
May just mean
I'm saying something.

Like "I miss you Friend,
I send you peace.
From mountain home
You left behind."
"What's that again?"
You're doing well in Never-land.

I Loved You Forward

I loved you forward!
Though I didn't know you best.
I did not have quite you in mind
When this quilt was made.
I made it for my daughter
Who had a child that grew,
Who had you.
This quilt will keep you warm at night.
I made each stitch straight, tight.
My love is cut into each block sewn here.
Like X's and O's at the bottom of a letter.
This quilt wraps you in my hugs and kisses.
Quilting is a woman's craft
Passed from mothers and aunts
To the young women in their lives.
How to cut the right line.
How to hold the needle.
Here let me show you,
Hold it so!
Old hands touch young hands.
The craft, the love,
is passed on in that touch.
You might not know me
But I loved you forward!

Back-Country Haiku

Ragged breath. Heart beat.
Mountain breeze. Birds tweet.
Back-country joys! No white noise.

Breathing/Skiing/Breathing/Skiing

The wind blows gently past.
Assuring me I do not have to grieve.
It will remain steadfast all summer
Now that seasons over
And we have to leave.
It will keep the mountain reaches cool,
help wild flowers nod their heads
And spread their seed.
It will study lessons
Written long ago in glaciers.
And ascertain that clouds fly
At perfect speed.
Then sometime after
Summer's last hot night
And in the season of
Autumn rain,
The wind will prepare once more for skiing
Look for our return again.

When You Leave

I love it when you leave this space.
You turn your face away from here.
In this vast and snowy, empty place
in the spring time of the year.

I get it back!
Much to my self.
To ski, or hike,
or just to view.

When you think
there's nothing fun.
Nothing left up here
for you!

All The Earth Is Holy

Jagged rocks and snow fields up high.
Trees, straight, bent or dead and bleached white.
Sunrise on rocky peaks or set on clouds
blown circular by distant winds.
The companionship of my best friend
and folks I'll never see again.
Energy of earth's making
and Dreams as stars rise to shine.
Meteors rush to vaporize to dust
and entertain beneath the Milky Way.
This is my ancient, holy place.
My Heaven.

You Comfort Me

For years your footsteps have been my heartbeat.
Taking you away
Or bringing you home.
Let me always be comforted by your footsteps.

For years your nighttime breathing has been my safety.
Gentle reassurance of security.
Within space of your embrace.
Let me always be comforted by your breathing.

Your voice, in anger or in laughter, center's me.
Asking me to focus on what we share.
Your voice, though not melodic, is a melody to me.
Let me always be comforted by your voice.

With Creator's grace, our spirits met and grew
And from them grew to unity.
That shines like a welcome beacon for me.
I will always be comforted by you.

We Are All Apart
We Are All A Part

Think of the smallest, smallest small?
Quarks, electrons, protons, neutrons.

Think of the biggest, biggest big?
Whales, Sol, constellations, imagination!

The Universe glows
In the Center of a poppy's bloom.

Or maybe the blooming poppy Center
Is a Universe.

A rain drop is a drop of life.
Plummet, splash, soak, grow!

As blood to us.
As life-blood flow.

We are not just WE.
And we won't wake up to see THAT

We are part of the biggest, biggest big.
We are all! Including the smallest, smallest small.

Bliss

Here I sit in brightest sun
Breathe in deep,
just for fun.
In that one breath
The world is whole.
My health is good
My loved ones live.
There is not one thing
That I miss.
In that one breath
My life is Bliss.

CatchUs!

We move so fast
We're hard for you to see or hear,
But you've seen us
And you know we're always near.

When the day comes
That you walk right by our side
You'll know you've reached
The Apex of the ride.

We can
Converse.
But...come,
Catch us first!

Spirit Family Home

I write these epitaphs for my beloved
As each one takes their leave.
But I wonder, with each parting poem
Who will write for me?

I believe in Spirit, truly.
And I know my loved ones wait
While they golf and paint and ski
Somewhere far past Heaven's gate.

Every day is Sunday Dinner
In the back yard Grandpa keeps.
It is green and welcoming
To my Spirit Family peeps!

I love this life upon the earth.
But the lesson's writ' in stone.
I am just a traveler here
On my way to Spirit's home.

My Little Life (4 pages)

It is so sleepy here.
The dogs rest in the street
Fanning ants with their tails on occasion.

I cycle, walk or drive down the street
And everyone knows me, or my car
They smile. They wave.

It is summer season.
The trees are friendly with
Their offer of shade.

The grass tickles my feet
Above the edge of my
Comfortable, worn flip-flops.

I hear the echoes of friends laughing.
Playing hop-scotch in the street
Until late at night.

I hear girlfriend whispers
Speaking of loves now lost
And plans for weekend fun.

There was always something to do.
Always someone to laugh with.
Adventure just a quick walk to the end of the street.

I remember Dad cooling his feet
In the cold sprinkler water
Coming right from the spring.

He watered our little patch of lawn
Religiously in summer
And always stopped to cool his feet.

I remember Mom planting flowers
In a halter that bared her
Long muscled back.

My Little life (page 2)

I remember a funny sunburn later
On that same bare patch of
Momma's white skin.

And the swimming pool
With the tallest bleachers
Made from the sawmill wood.

Lifeguard Judy, behaving us with her whistle.
Teaching us to swim, to float
On our tied blue jeans.

So we can plunge
in the cold waters of the McCloud
From Fowler's Falls

Swim at Tate Creek Hole
At Sally's Hole or Camp 4.
At Delta with summer friends who left us early.

Swim with family, later with friends who drove.
We are soaked in the sacred waters
Of the Sacramento and McCloud.

We think we are free.
We explore, crossing imaginary lines
But we are watched.

By grandparents, both sets
And great grand parents and uncles,
Aunts and cousins.

All ready to spoil us,
Show us something new.
Care for us. We were safe.

Summer changed to Fall.
Deer tags filled and filled our freezer.
Mom and Dad provided.

My Little Life (page 3)

Camp in the dry lava beds.
With Helen's pepper pot stew
And piles of food brought for weeks.

Water, scarce here,
Found at Indian Spring.
Later we could drive for it.

Military jeeps that only ran in the Fall.
Full of snoose cans, lava dust
And men's' leavings.

Soft dust was our Fall makeup
Showing only bright eyes and teeth.
Dusty, sunny smiles hunting with our family.

Then leaves colored up and fell.
Tree skeletons holding their arms to the sky
Praying for winter.

North winds blew the snow
Into town and plows pushed it high
Barricading street sides.

First white and clean,
Mill soot colors snow in funny, gray
Snow-melt patterns.

And rain, after the third day
Comes to knock down the pile
And more snow comes.

The burmes at the side of the house grow
To enclose our windows.
Shoveling over 5, 6 or 7 feet piles.

It is a wonderland
And us kids use it all.
It's there for us.

My Little Life (page 4)

Then we learn to ski.
Above tree line in the
Sacred space on Mount Shasta.

Just us. A family event.
Our family includes ski-family
Sharing our full freezer and more.

With new friends from small county cities.
Life-long friendships flourish
In our sleepy north-state.

Then warm breezes blow.
The snows melt
Rivers run full and full of fish.

We visit the McCloud, the Sacramento.
The Fall, the Shasta.
All of them cool.

River secrets shown to us.
Floating goose eggs, fresh water mussels,
Angry muskrats, shy turtles.

Spring here brings buds, blooms, bugs.
Old friends seen
Once a year at Fiesta.

But sometimes I remember it
Being still and quite.
Only tree leaves waving for attention.

It is so sleepy here.
The dogs rest in the street
Fanning ants with their tails on occasion.

~ THE END ~

www.ingramcontent.com/pod-product-compliance
Lightning Source LLC
Chambersburg PA
CBHW081307180526
45170CB00007B/2597